ADULT

COLORING

BOOK

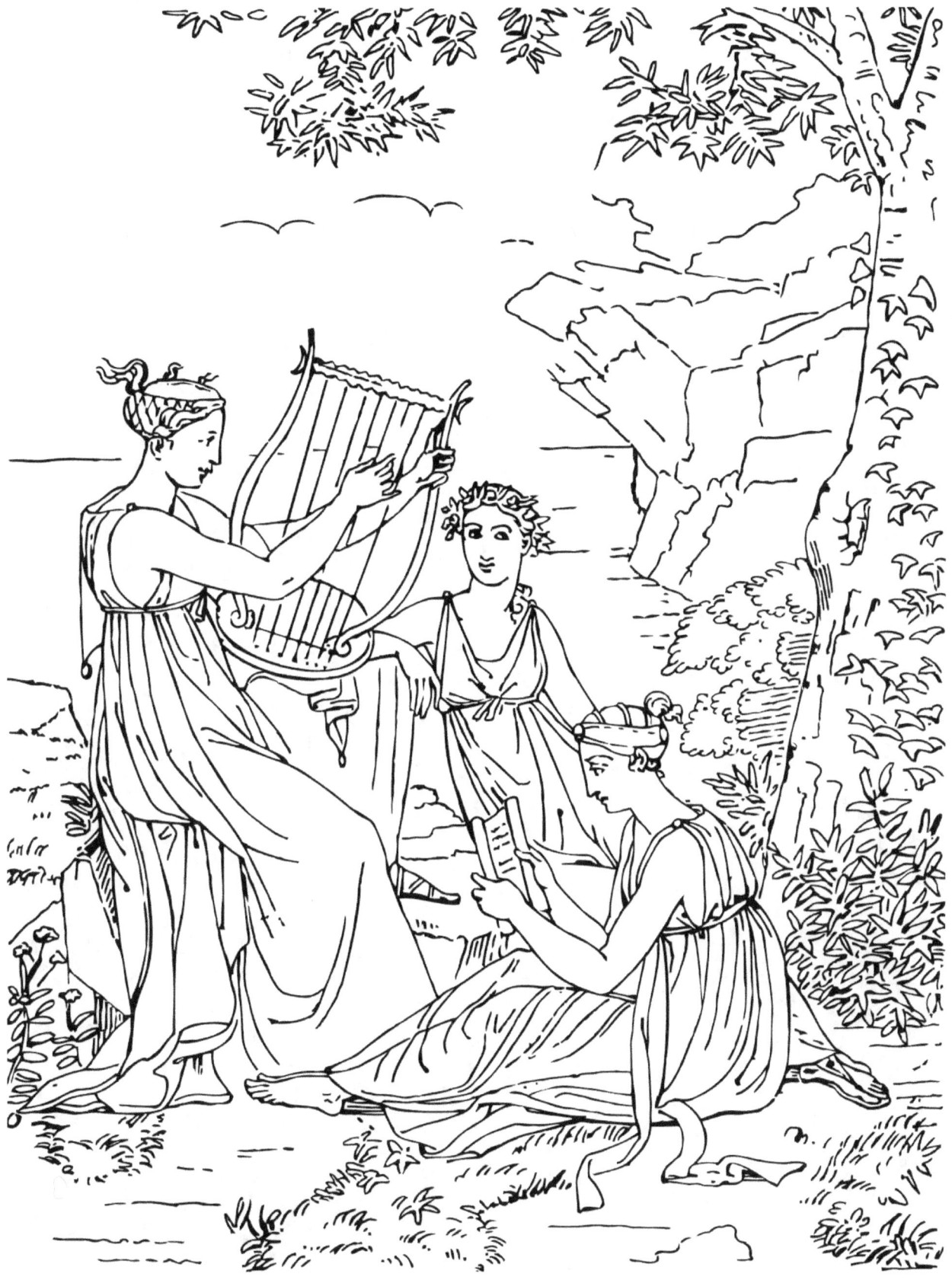

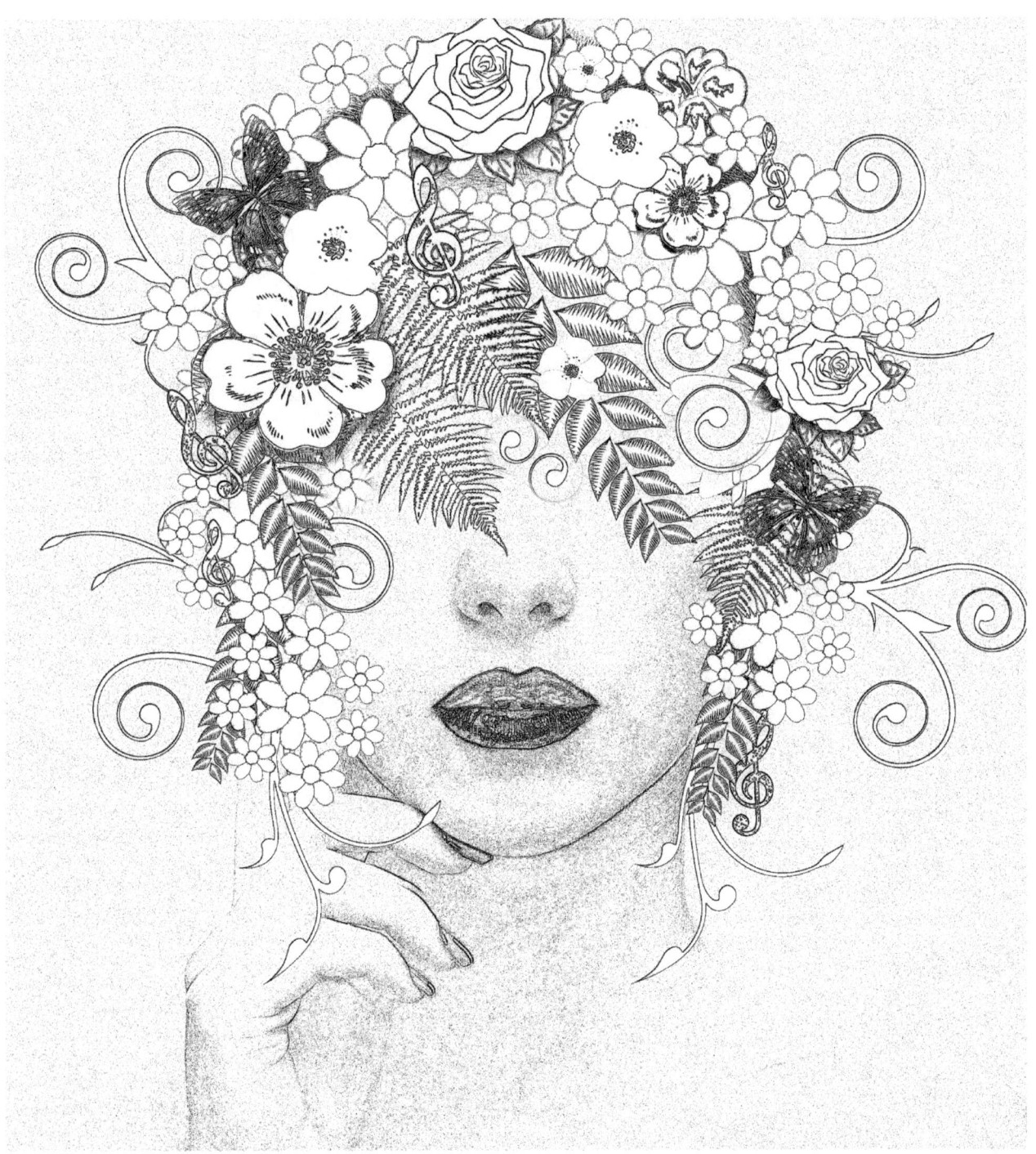

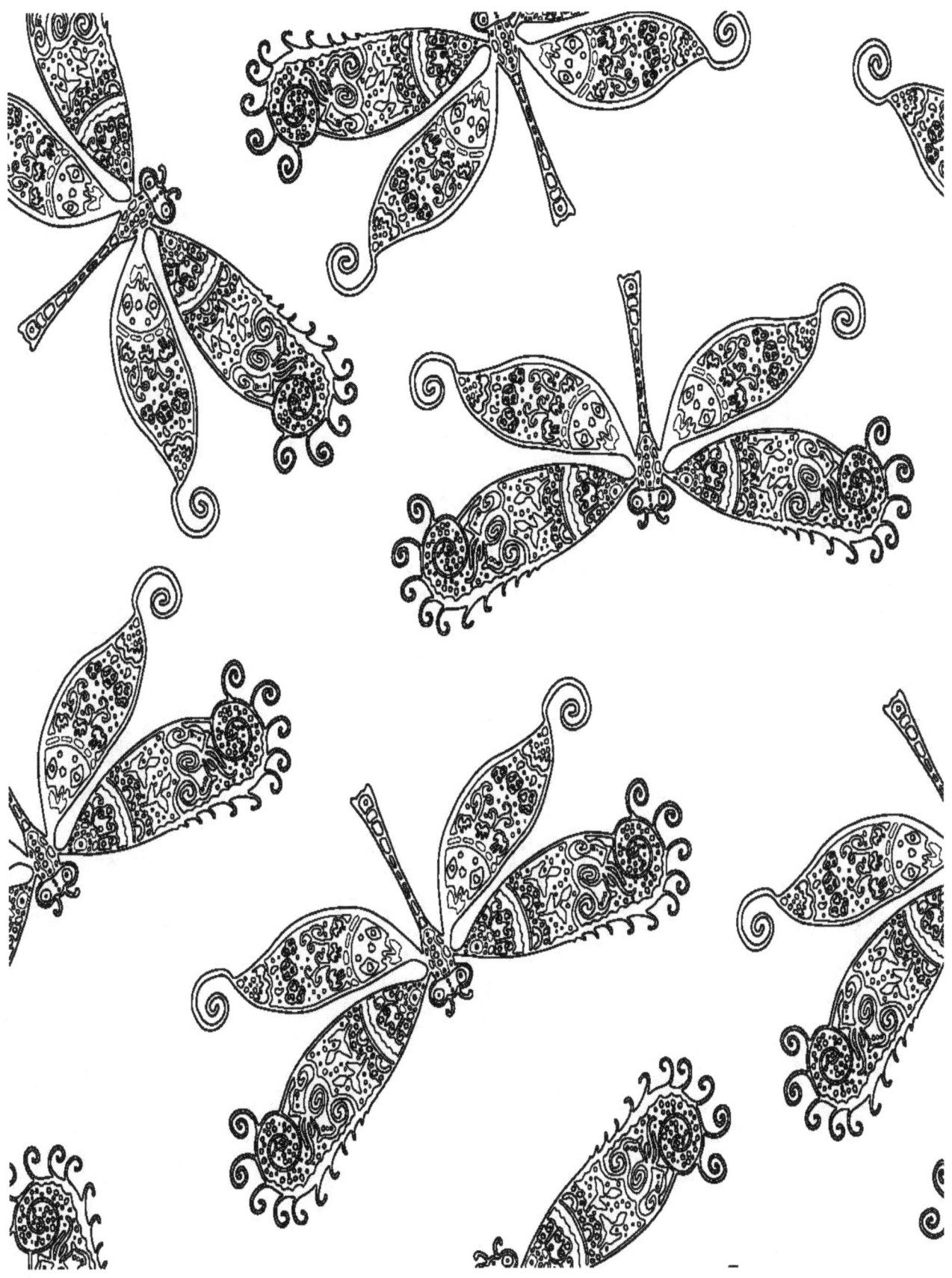

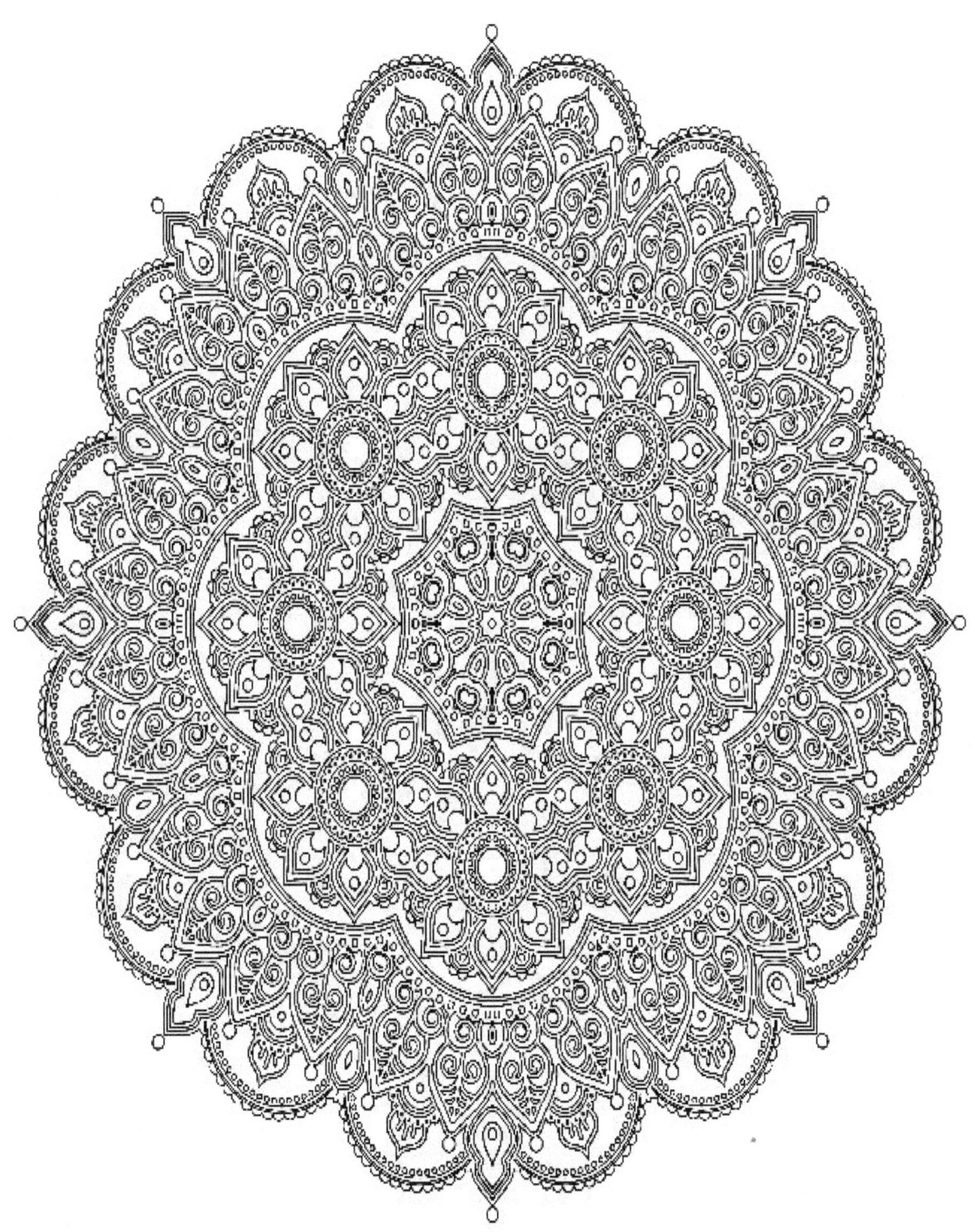

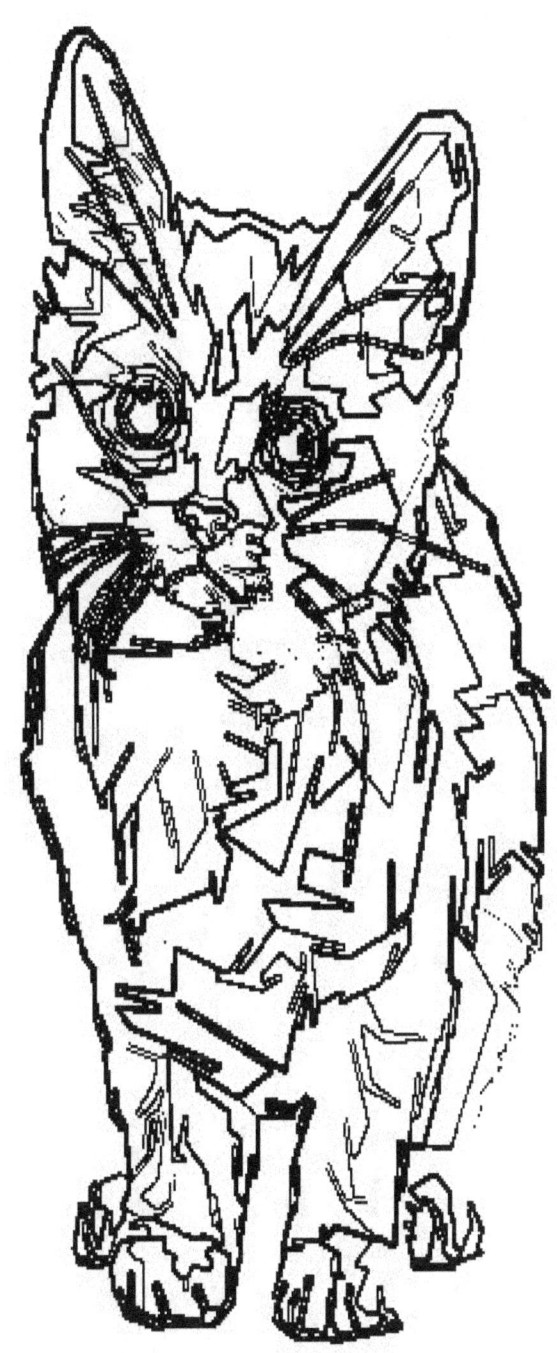

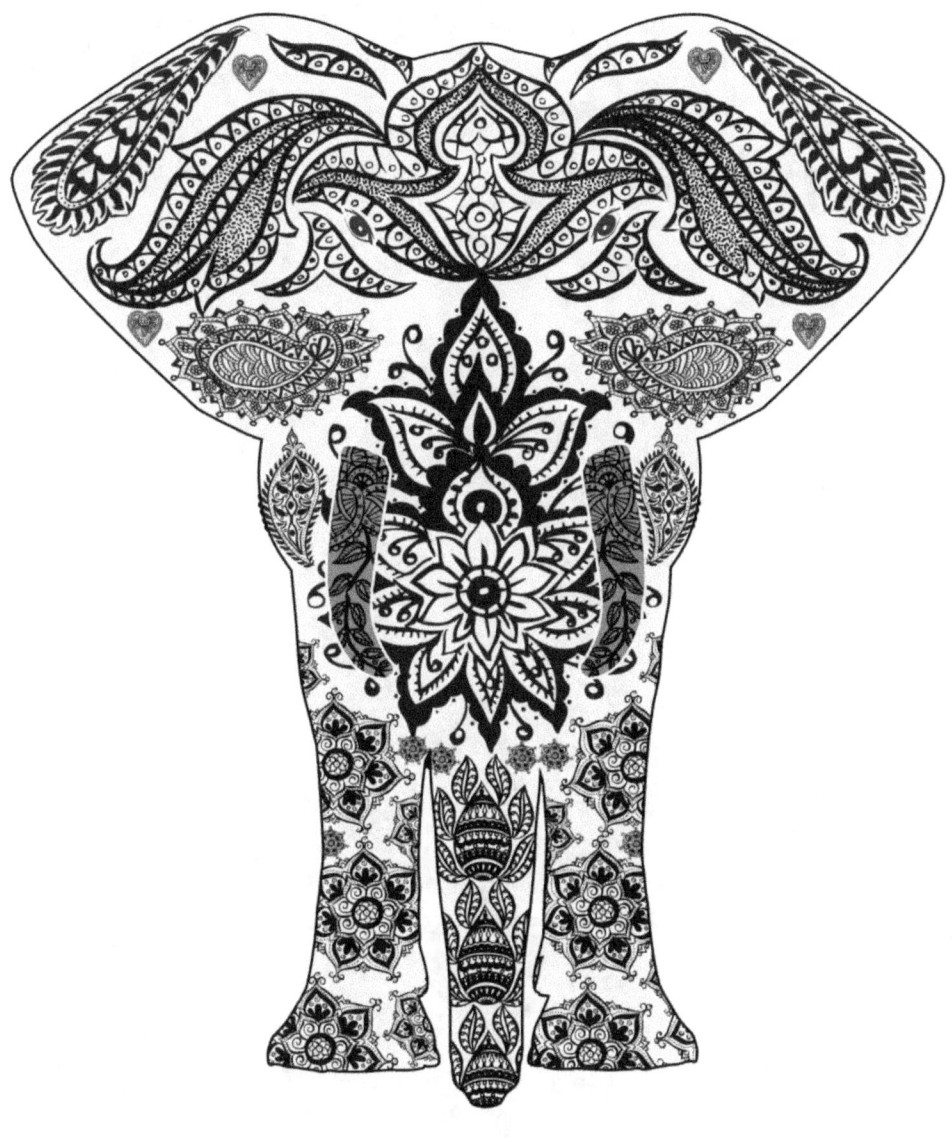

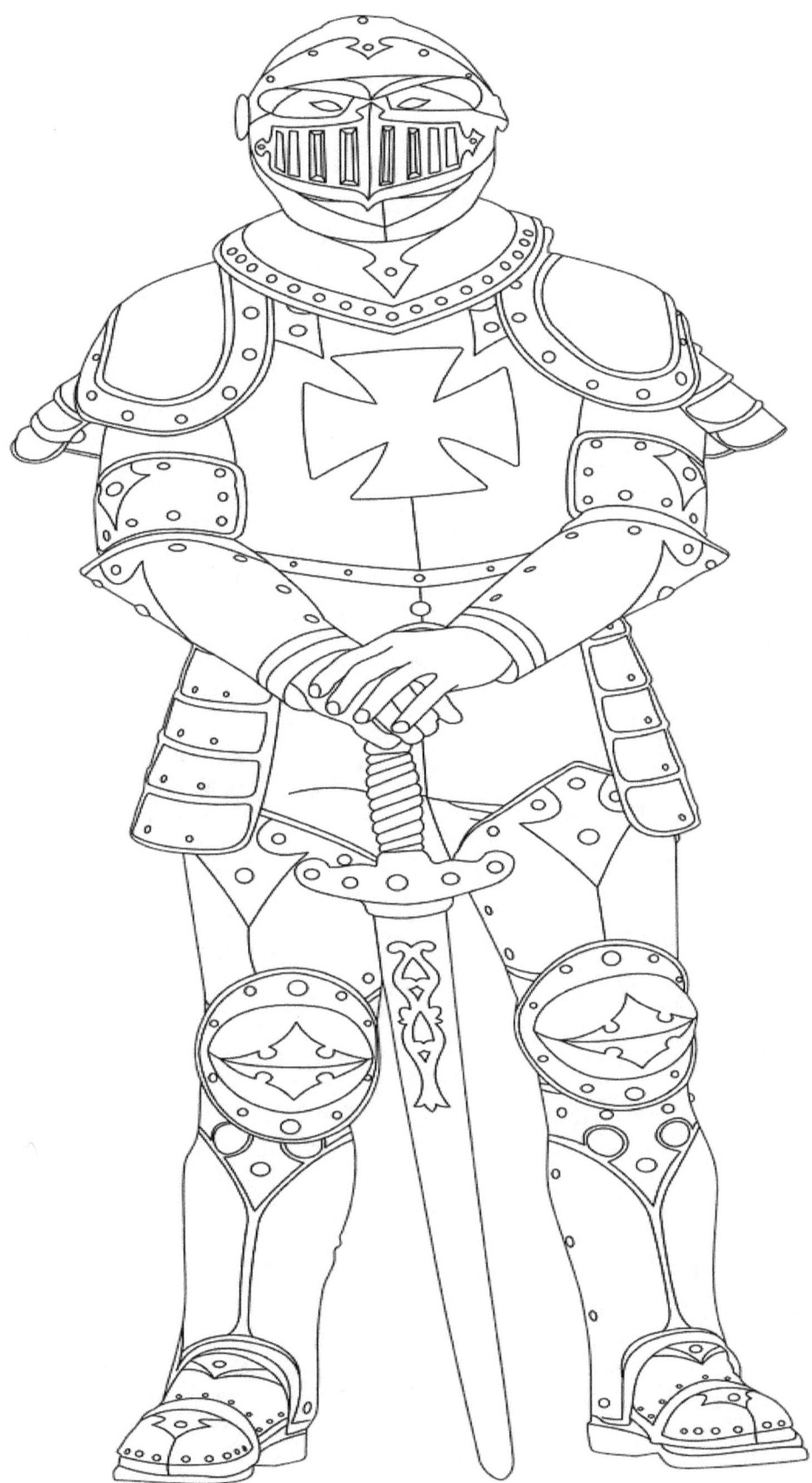

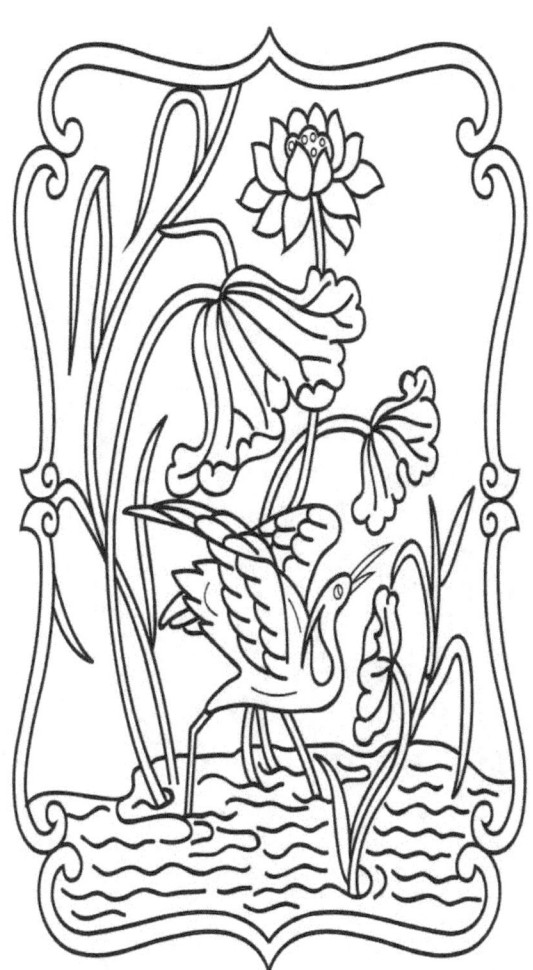 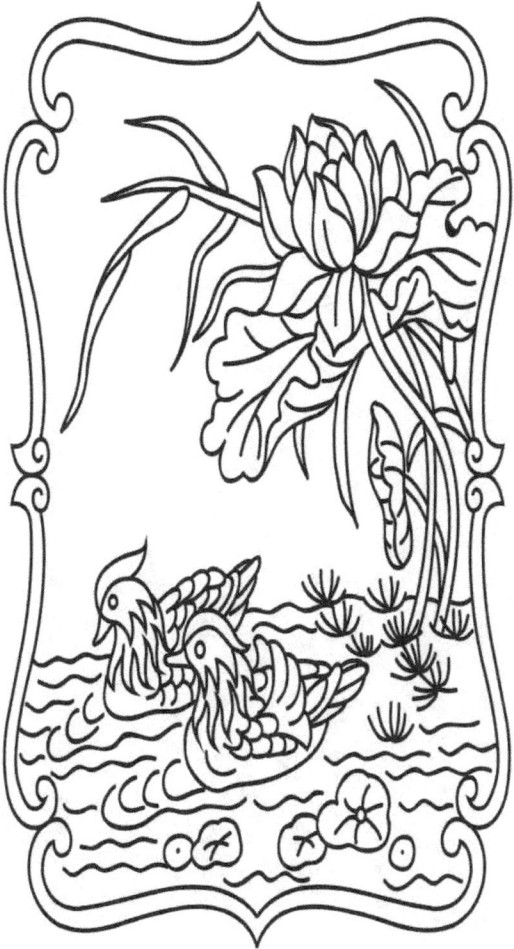

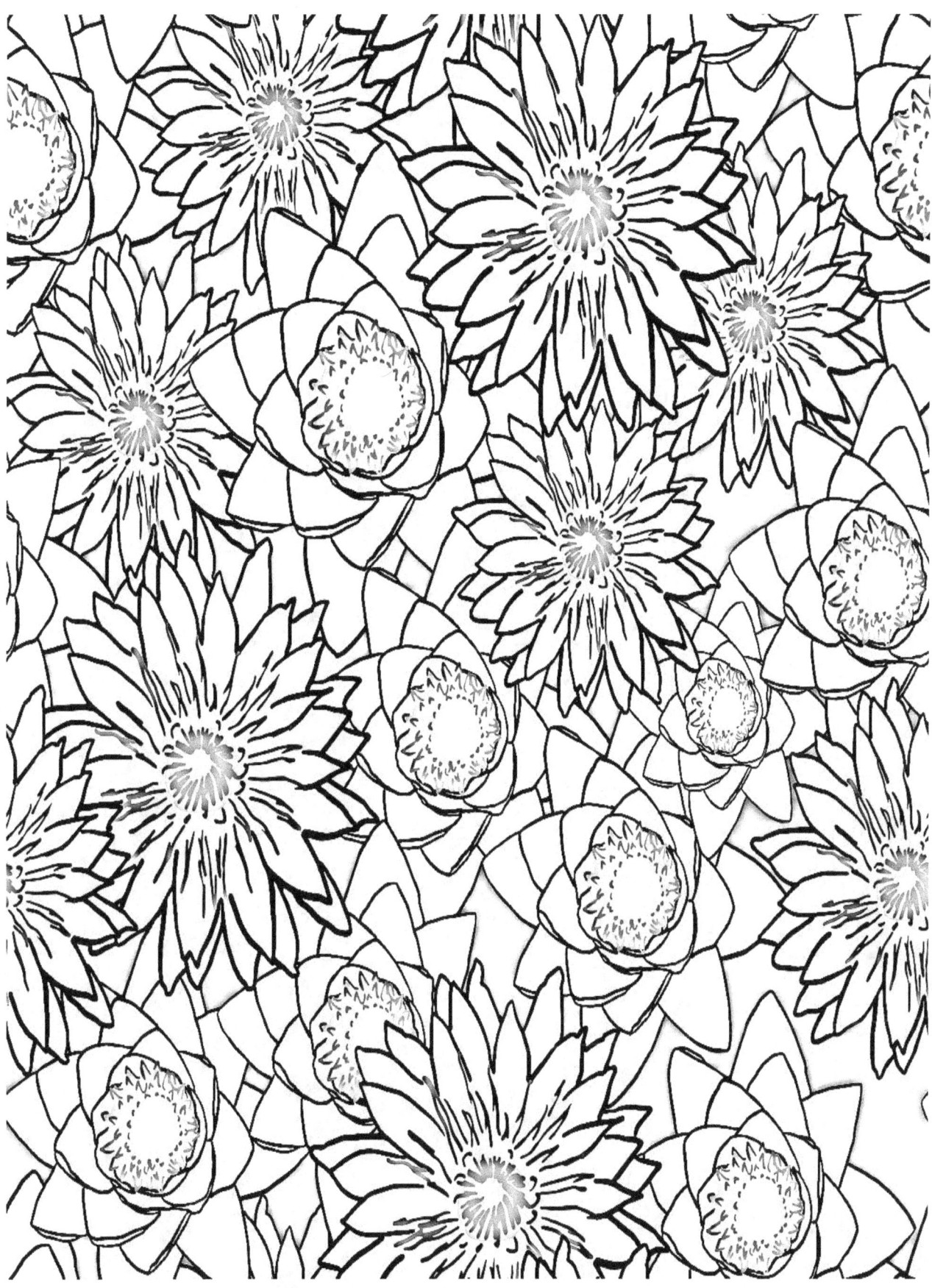

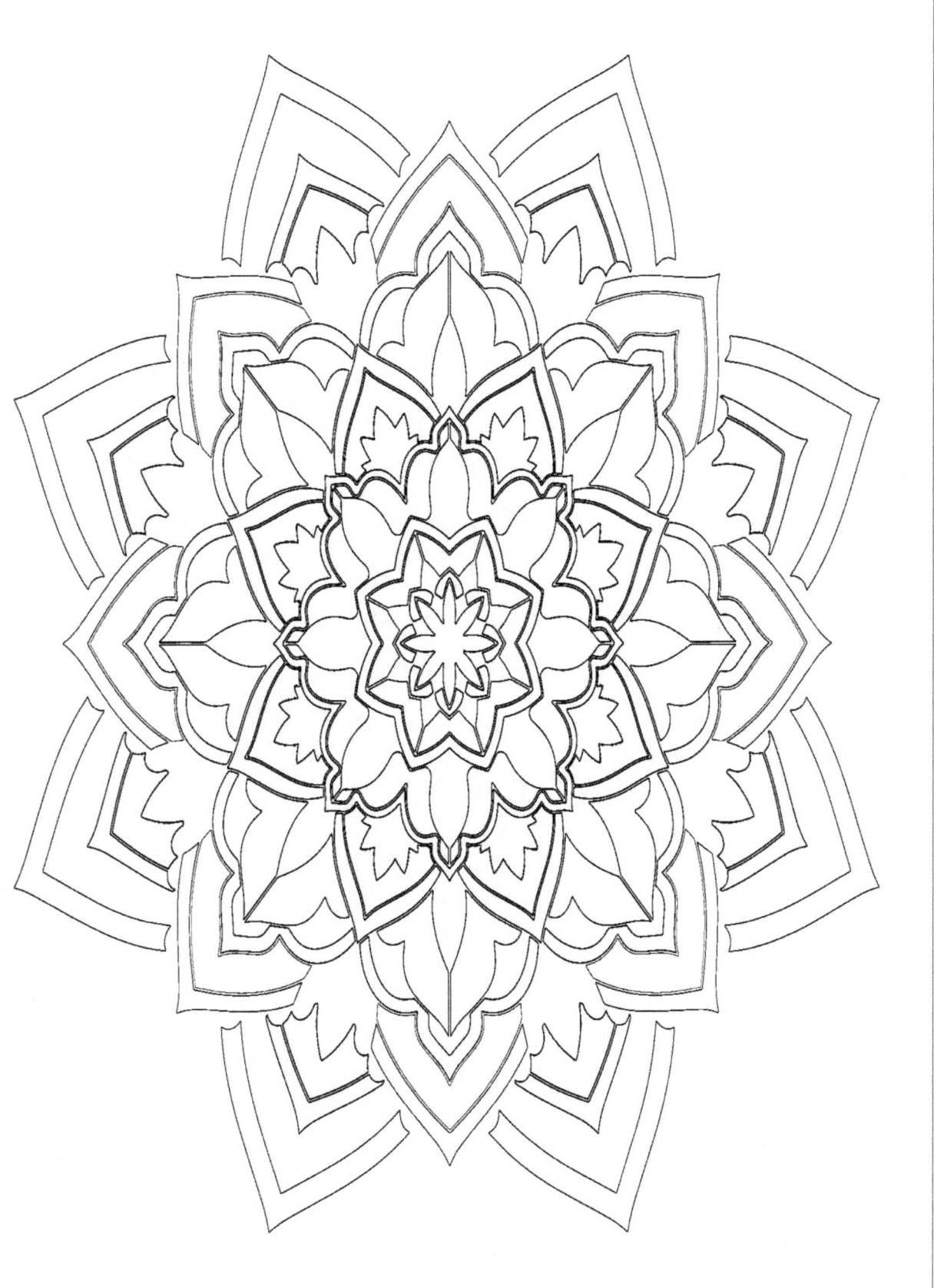

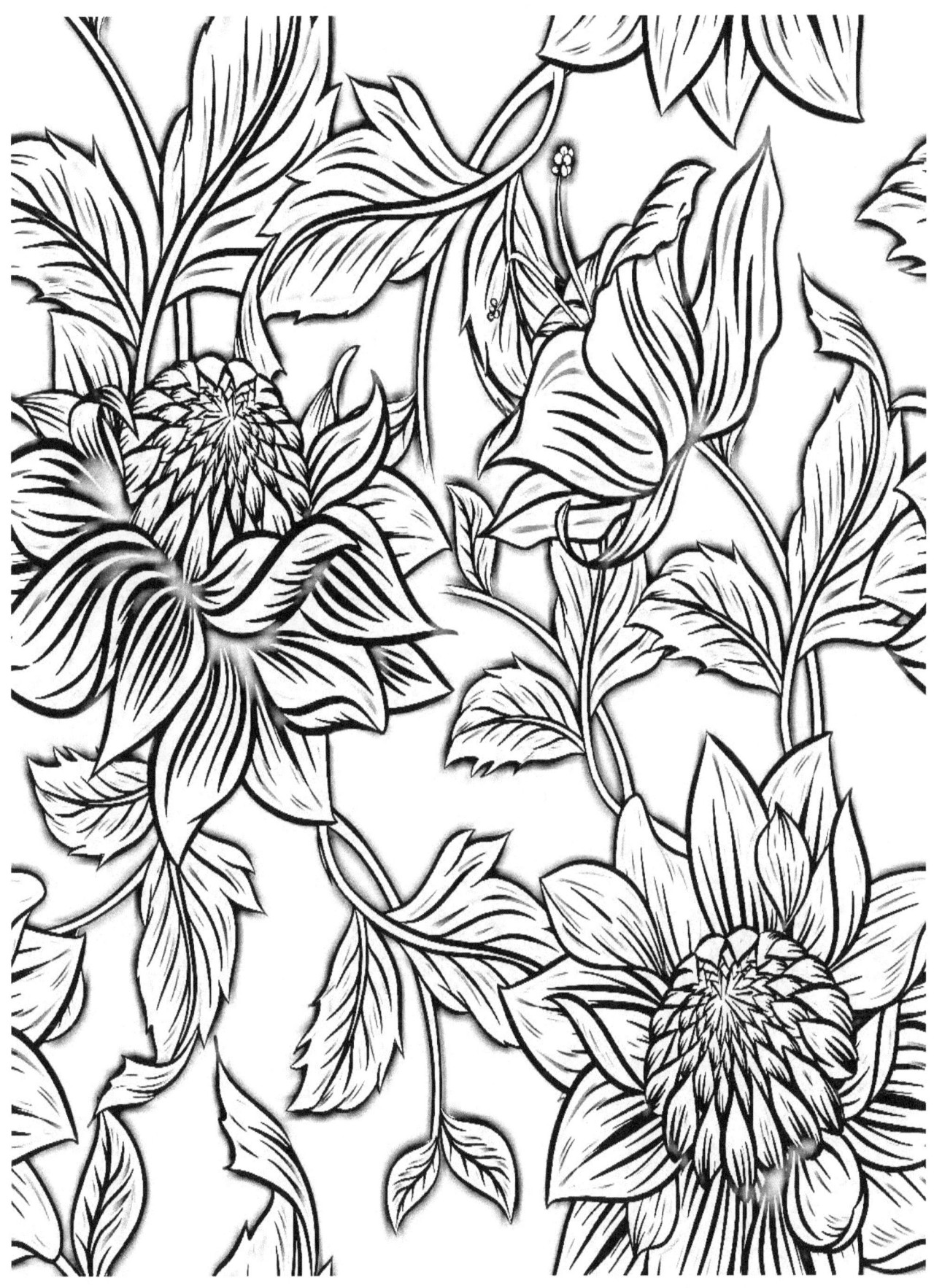

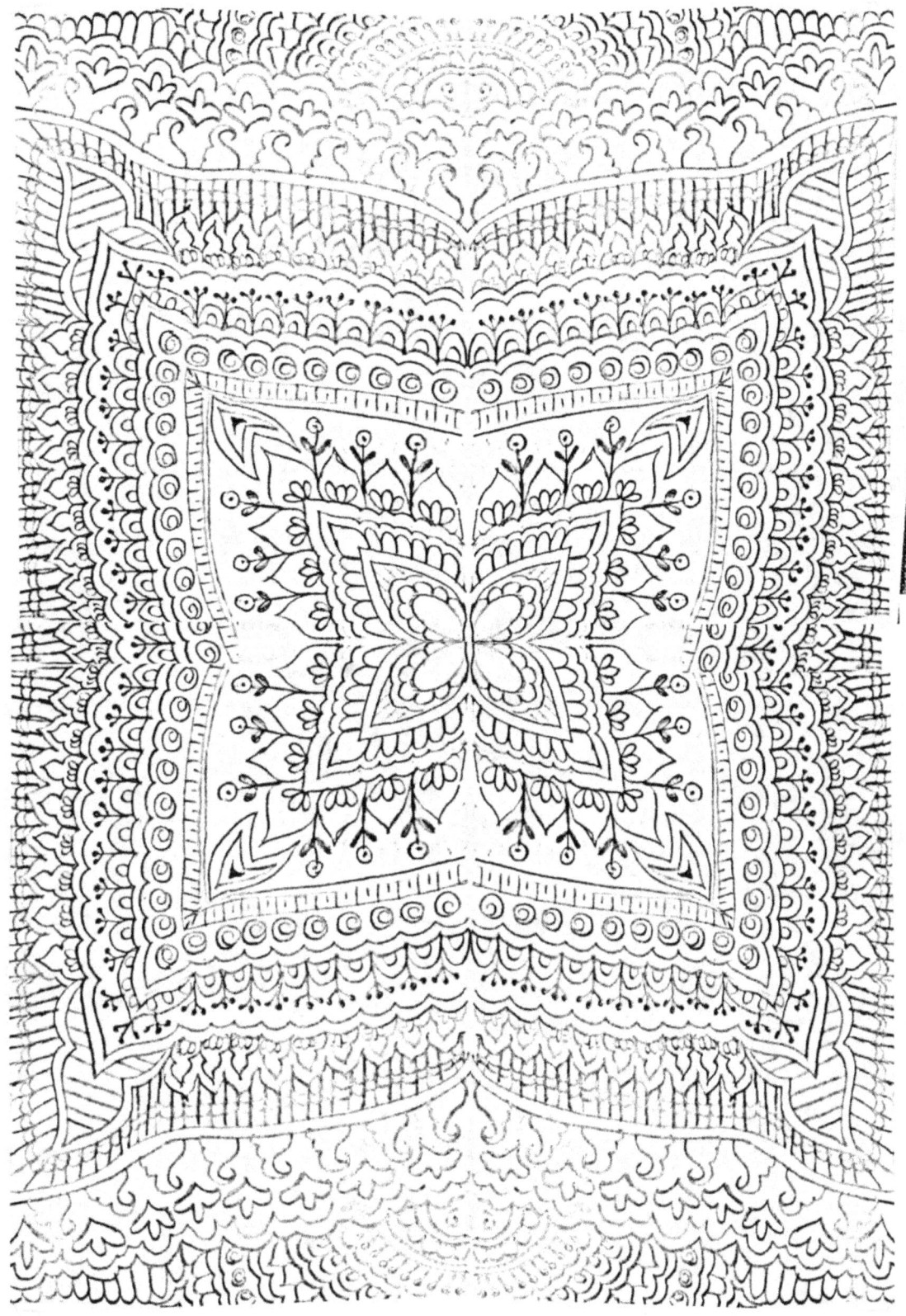

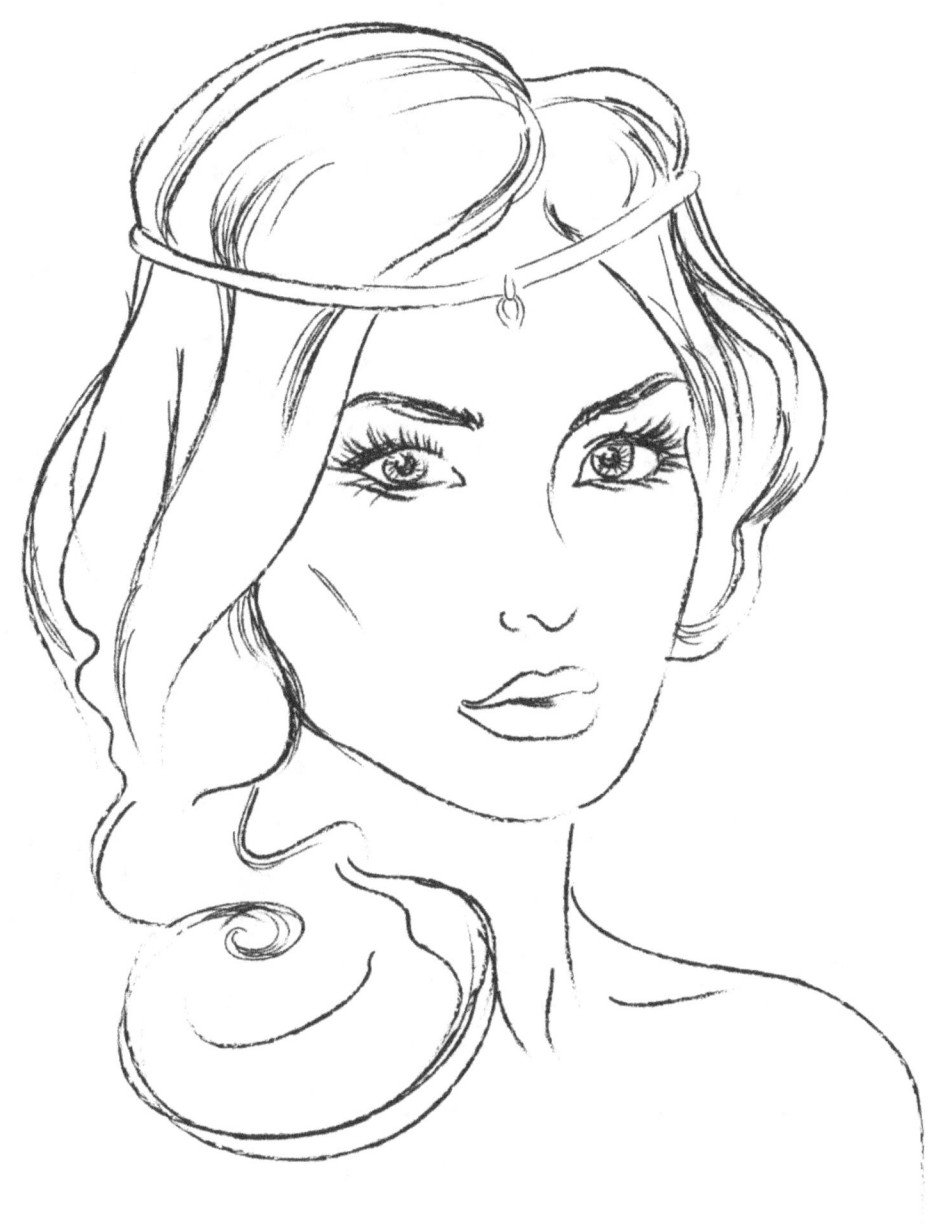

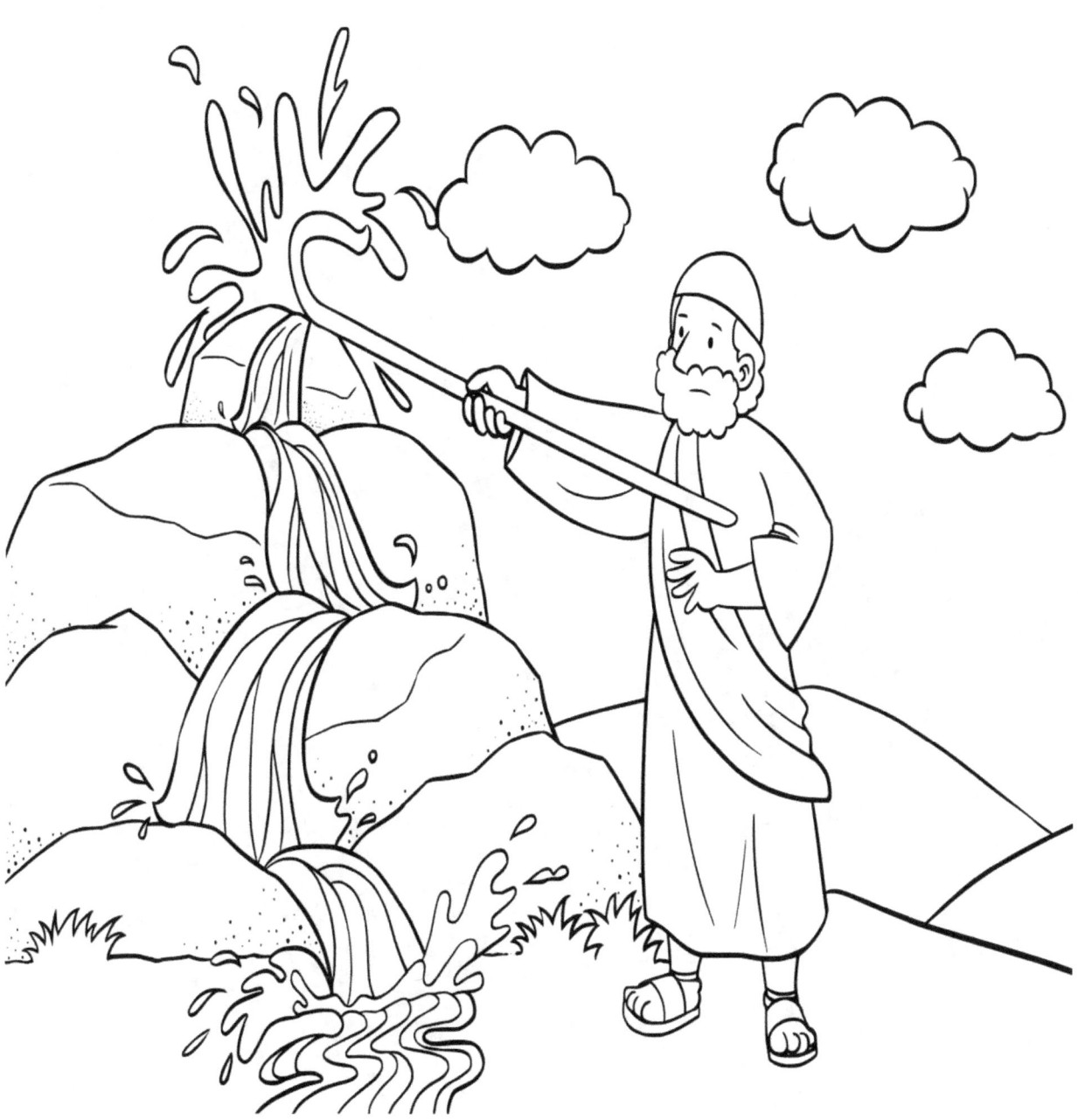